DON JUAN

Moliere

DON JUAN

in a translation by Neil Bartlett

OBERON BOOKS
LONDON

This translation first published in 2004 by Oberon Books Ltd
521 Caledonian Road, London N7 9RH
Tel: 020 7607 ‍337 / Fax: 020 7607 3629
e-mail: oberon.books@btinternet.com
www.oberonbooks.com

A catalogue record for this book is available from the British
Library.

ISBN: 1 84002 439 9

Printed in Great Britain by Antony Rowe Ltd, Chippenham.

Contents

INTRODUCTION

This Play

IN 1664, MOLIÈRE'S COMPANY performed (at court) the first version of *Tartuffe,* a comedy he had written attacking the hypocrisy, religious and otherwise, that he saw infesting his society. The piece was promptly banned, after pressure from the religious authorities was brought to bear on the King. This meant that Molière and his actors were left without a new play with which to open the spring season of the following year. So, of all the things he could have written, having just caused this dangerous scandal, he wrote *Don Juan.*

It was a huge success (with Molière leading the company himself in the role of Sganarelle). But once again pressure was brought to bear, and although not formally censored, the play was never again performed in Molière's lifetime. Even when, following his death, it was eventually printed, several of its lines and almost all of one scene (the scene where Don Juan tries to bribe a beggar into blaspheming) were considered so offensive that they had to be omitted.

The censors who made these cuts made a huge mistake. They thought that the danger of the play (the darkness that glitters constantly beneath its comedy) resides in the fact that its two leading characters say terrible things (and make terrible jokes) that explicitly challenge all conventional ideas about sex, religion, marriage, authority, morality – to summarise Sganarelle's opening speech about his master, you name it, Don Juan doesn't believe in it. In fact, the dangerous thing about the play is that nothing about it is explicit; everything about it is vitriolically ambiguous. Its irony is not only corrosive; it is all-pervasive.

This isn't just a question of individual lines – though it is true that one of the things that links Sganarelle and Don Juan together in their unholy symbiosis is that they share a talent for speaking the truth whenever they seem to be lying, and for lying (or joking) whenever they seem to be speaking the truth. The whole play is a web of ironies and ambiguities. Just for starters,

how can a series of scenes clearly set up to be funny be so disturbing, and how can such a cruel and disturbing story be funny? What are we supposed to think; does this play show us a wicked member of a corrupt ruling class being justly punished for his moral, sexual and financial (and intellectual and spiritual) sins; or does it set up that expectation precisely in order to then show us a man whose libertine promiscuity, whose active espousal of hypocrisy and blasphemy, whose all-round refusal to pay any of the moral, sexual and financial bills that the rest of us organise our lives around paying, makes him not only powerfully attractive, but even some kind of revolutionary existential hero? Surely the hellfire ending of the play is a deliberately ironic, transparently fake nod to convention – or is it, in the strangest of double ironies, meant to terrify? Does anyone in the play actually meaningfully believe in the God, devil, hell and damnation they so frequently (casually?) invoke? Is the Don, who everyone else is sure does not believe in God, perhaps actually seeking in some perverse way to provoke Him into re-appearing? We know how the conventional mythology depicts him as the world's greatest hedonist, and how the other characters talk about him, but would you say that in this play that the Don is addicted to sex, or hungry for sex, or scared of it, or sick of it? Are his crises those of a man bored of life, or in love with it? Or is he in love with death – why else would the great seducer invite a guest, in this case the Statue, to dinner, if not to make love to them, to add them to his list of conquests? Why does a man so famously heartless act like a man of great heart? Why is this coward so brave – or this brave man so cowardly? And, speaking of cowards, is Sganarelle, who can turn a tight corner just as fast as his master, stupid – or very, very clever? And so on…

The actors who play the piece have of course to make their choices in answer to all these questions. Molière's text revels in keeping anyone who reads it or watches it guessing, anxious, disturbed, amused. One of the things that intrigues me most about it is that in a play so full of words – brilliant, energetic, marvellously phrased words – the title character's weapon of choice is often a dangerous silence.

This Translation

With the exception of some minor cuts, mostly in the original's rather long-winded third-act satire at the expense of Dona Elvira's pompously upper-class brothers – which I'm sure went down a bomb at Versailles in front of an audience composed almost entirely of Don Carloses and Don Alonses, but would rather tire a modern audience – this is the play as Molière wrote it.

I should note that I translated the play on the assumption that I would cast a Don whose vices are not those of a young peacock, but those of imminent middle-age. His temper still flashes, but his melancholy is that of an experienced pornographer. Although he ends almost every scene by saying that he wants to leave, move on, go somewhere else, the play gives an incredible sense of entrapment; everything that he does and says is freighted with the sense of a man seeking something – anything – new. Violence, for him, is a stimulant. So is the challenge of seducing a nun. So is the challenge of proving to the audience that he can stoop as low as seducing a working-class hotel maid, twice, in under four minutes, without damaging either his vanity or his reputation. And for all his ostentatious self-confidence, Don Juan seems to me to be a man on the run – from Dona Elvira (the only woman on his list of conquests who is his social, intellectual and emotional equal), from her brothers, from his Father, from his creditors; from feelings, from love, from sex, from a terrible sense that there may be nothing new under the sun. One can imagine that the nightmares of the play's final page are those of a man who should have seen the grand finale of heart-attack, burn-out or stroke coming some time ago.

The heart of the play is a double-act, not a solo; so, a word about Sganarelle and why it seems to me that Molière gives him the particular way of phrasing himself that he has, a phrasing for which I have tried to create a credible English paralell. Sganarelle has been working for the Don for years, and also, clearly, playing Sganarelle for years. His actor's /comedian's / clown's relationship with the audience – the fact that he can talk directly to them (so long as it is behind the Don's back or over his head) – immediately sets the tone of this particular kind of dangerous comedy.

The stage directions in this published version of the script are Molière's original ones. I have also kept to the original time-scheme of the play, which is, in realist terms, confusing – it is not quite clear how many days the literal action spreads over. But in poetic, or theatrical, terms, it couldn't be simpler; the play starts with the Don turning up late one morning; then it keeps on getting later, until it is very late; and eventually it is too late, and Time doesn't matter any more, because it has run out.

The Lyric Production

This translation was made for the Lyric Hammersmith. Economy dictated a single setting as opposed to the elaborate changing scenery which we know was used in Molière's own staging at Versailles in 1665. As it turned out, this apparent problem turned out to be a solution. Everything happened in the same place. The curtain rose on an expanse of red carpet, with the odd touch of gilding and black marble, evoking the sometimes sinister, sometimes debauched world of a grand hotel. The almost-infernal red of the Lyric's *fin-de-siècle* colour-scheme, carried up onto the stage, also suggested that somehow Don Juan wasn't just going to end up in hell; he was already, privately, in it. The continuity between stage and auditorium was also apt for a play in which audience and characters, at Sganarelle's insistence, are all in the same room from page one.

This hotel-lobby setting deliberately placed the whole action in several different kinds of limbo. This was a space where the Don is in transit, restless, on the run. Interventions by a mysterious, hovering team of salaciously uniformed hotel staff took us from the lobby to the Don's room late at night without the sense of a single, theatrical, out-of-time, out-of-place setting ever being broken. If this was a hotel, it was one the Don could never really check out of. Even when the action apparently moved elsewhere – when the Don temporarily wanders in the mid-life-crisis dark wood of Act Three – I still wanted the audience to feel that he is going nowhere except deeper inside himself. At the Lyric, leaves blowing across the carpet amongst the furniture took us into the wood; an echo took us into the tomb.

The sense of limbo extended to language and costume. Reflecting the chameleon verbal quality of the original, at times the Don affected to speak as if he was in *The Picture of Dorian Gray*; at other times he was clearly addressing the audience in the language of their own, class-ridden city. The uniforms of both the aristocrats and their staff could have been worn with equal conviction at Wilde's Savoy, von Aschenbach's Lido or even in the deranged corridors of Kubrick's more recent hotel *enfer* in *Eyes Wide Shut*.

The ending of Molière's play calls for expensive and spectacular special effects – walking statues, ghosts, fireworks, trapdoors – in the Italianate style popular at the time. All of these features of the play had to have, in this particular staging, a double, poetic reality. While Sganarelle might insist on hinting to the audience that he knows that the Statue is just an actor pretending to be made of marble or bronze, and that the final apparitions are stage tricks, the audience could also think that they are exactly the kind of subconscious hallucinations that might credibly populate a mind like Don Juan's. That the Statue might be, quite simply, a nightmare of the one thing which Don Juan *really* doesn't believe in; his own death. That, for instance, the figure of a veiled nun transforming itself into an image of vengeful 'Time' could be read as a guilt-fuelled image of an ageing, grieving Dona Elvira – the only woman he was ever actually in danger of loving, the only woman who could, threateningly, have been his equal. And that his final screams are those of a middle-aged man who can't quite believe that he is dying alone, in pain, in a hotel room, haunted by a very personal set of demons, rather than those of someone who is being dragged down a trap-door by theatrical stage devils.

This translation is respectfully dedicated to the memory of Robert David MacDonald, an encounter with whose writing was one of the things that first made me want to make nights out in a proper theatre – and, of course, to the actors who first performed it.

Neil Bartlett

Characters

SGANARELLE
Don Juan's manservant

GUSMAN

DON JUAN TENORIO

DONA ELVIRA

PIERROT

CHARLOTTE

MATHURINE

A POOR MAN

DON CARLOS

DON ALONSE

DON LOUIS TENORIO
Don Juan's Father

A STATUE

MR SUNDAY

This translation was first performed at the Lyric Hammersmith on 30 September 2004 in a production created by the following company:

SGANARELLE, Paul Ritter

DON JUAN, James Wilby

DONA ELVIRA, Felicity Dean

DON LOUIS, Giles Havergal

GUSMAN, DON ALONSE, A POOR MAN,
 James Bellorini

PIERROT, DON CARLOS, MR SUNDAY, Giles Fagan

CHARLOTTE, Kirsty Bushell

MATHURINE, Patti Clare

A STATUE, Gregory Cox

Directed and Designed by Neil Bartlett

Lighting by Bruno Poet

Sound by Nick Manning

Assistant Designer, Nicolai Hart Hansen

Assistant to the Director, Chris Rolls

Company Stage Manager, Bo Barton

Deputy Stage Manager, Heidi Lennard

Assistant Stage Manager, Bella Lagnado

Casting, Siobhan Bracke

Costumes, Lyric Hammersmith Wardrobe

ACT ONE

Scene One

SGANARELLE with a tobacco-box.

SGANARELLE: Never mind your Aristotle; never mind your philosophy; no pleasures can compare to those of nicotine. To be civilised, is to smoke. All gentlemen smoke – in fact, if one doesn't smoke, what *is* the point of living?: it doesn't just cheer you up you know, smoking, doesn't just clear your head; it can actually, unlike philosophy, make you a better person. Make you, more of a gentleman. You watch them, smoking; how polite they are; how they hand them round right left and centre – they don't wait to be asked; no, they *offer*. They *divine the needs of their fellow human beings.* In fact, smoking can make a nicer person, a *better* person, of anyone who takes it up. I thank you.

Right, where were we?

So, Gusman old boy; Dona Elvira, your mistress, surprised by our sudden departure, has come running after us, has she?; and her heart, the depths of which Don Juan, my master, has plumbed so expertly, is in imminent danger of breaking if she doesn't catch up with him, is it? Shall I tell you what I think? Just between you and me, Guzzy, I'm afraid that, one, she is going to get her heart broken; two, her trip here's going to be a wasted one; and, three, you'd have been better off staying at home as well.

GUSMAN: Really? But why – why are you so sure it's all going to be such a disaster? He must have said something – must have dropped a hint as to why he suddenly just…upped and left?

SGANARELLE: No, he hasn't – he doesn't; but, given the familiarity of this particular scenario, I think I can hazard a guess as to the likely reason. I could be wrong; but, you know, I have seen it all before.

GUSMAN: No! You mean he ran off because he's already got another woman on the go. How could he do that to a Lady like Dona Elvira –

SGANARELLE: No; he ran off because he's a coward.

GUSMAN: But he's a gentleman –

SGANARELLE: He certainly is. Amazing, isn't it, what they can get away with?

GUSMAN: But he promised to marry her. In Church.

SGANARELLE: Yup... – Gusman; Gusman old boy, you have no idea, no idea at all, do you; he's...he's Don Juan.

GUSMAN: You're right, I've no idea how anyone goes around treating people like that. And I don't understand why we had to go through all that keeping on at her, all those promises and letters and late-night messages, all that begging and nervous breakdowns and weeping – not to mention his going berserk and finally breaking into a convent, a holy convent, to get at her – if: well I don't understand how a man can be that much in love and then break his promise.

SGANARELLE: I don't quite see what's not to understand myself: and if you knew Don Juan like I know Don Juan...you'd know that for him, breaking a promise is as natural as breathing. Not that I'm saying I know for certain that he has found an actual replacement for your Dona Elvira – he may, or he may not; like I said, he sent me on ahead with the luggage, and I haven't actually seen him yet this morning – but the thing is, you see, just to give you an idea – and this is strictly just between the two of us – Don Juan, my master, is,

quite possibly, the worst villain the world has ever seen:
he's a maniac; an evil, brutal, heretical – he doesn't
believe in God!!… – Heaven, Hell, Saints, Virgin Mary,
vampires; nothing – a beast; a beast I tell you; a real
animal; morals of a pig in a trough; a Caligula; Nero
the Second – sticks his fingers in his ears whenever
religion's mentioned, and laughs in the face of
everything decent folk like you and me hold dear. You
say he promised to marry your mistress in church;
believe me, he'd've married you, your sister and your
dog too if he'd had to, to get his wicked way with her.
As far as he's concerned, marriage is a piece of paper;
old ladies, young ladies, housewives, farmworkers – he's
nothing if not Catholic; if I showed you a list of all the
names of all the women he's had, it would stretch from
here to breakfast-time. Shocking, eh? – and you think
that's grim, that's just the outline, you wait till I fill in
the gory details…well; I'll just say, it's all going to catch
up with him one day, and leave it at that. The things
I've seen, working for him – it turns my stomach,
sometimes – I tell you, there's been times I've wished
him straight to…but I don't say anything, because a rich
man with no morals is a terrible thing: a very
unpredictable beast; and if you work for one you have
to keep it buttoned and do what you're told. That's
right; I may smile,and smile, and give it the old 'yes sir,
no sir', but in my heart of hearts, I think he's –

well talk of the devil…

Shift – I don't want him to see you talking to me; and
listen, that last bit was just between ourselves, alright?; I
got a bit carried away with myself there. If one word of
that ever gets back to him, I'll tell him it was you said
it, not me.

Scene Two

DON JUAN: That man you were just talking to, doesn't he work for Dona Elvira?

SGANARELLE: That's more or less the general picture yes sir.

DON JUAN: Does he or doesn't he?

SGANARELLE: He does.

DON JUAN: And how long has he been here?

SGANARELLE: Since last night.

DON JUAN: And what was he asking you about?

SGANARELLE: Well as you can probably guess sir, –

DON JUAN: Our sudden disappearance, I imagine?

SGANARELLE: The poor man's in quite a state about it, and was asking me why it had happened.

DON JUAN: And what did you tell him?

SGANARELLE: That we hadn't discussed it.

DON JUAN: Nevertheless, I'm sure you've formed a personal opinion on the matter.

SGANARELLE: Personally, not wishing to jump to any conclusions sir, I should say you're probably planning your next affair already.

DON JUAN: Would you?

SGANARELLE: Yes.

DON JUAN: Well heavens above, you'd not be wrong. You may as well know; I am planning a replacement for Dona Elvira.

SGANARELLE: Well Good Lord, if that isn't my Don Juan right down to the tips of his fingers; the world's number

one womaniser, eh? – always on the prowl, always footloose and fancy free.

DON JUAN: And you don't approve.

SGANARELLE: Well...sir...

DON JUAN: Well what? Speak.

SGANARELLE: Well obviously there's nothing to disapprove of, if that's how you want to live your life; so one wouldn't. But, if that wasn't how one wanted to live one's life, well then, yes possibly, one would.

DON JUAN: Would one? Disapproval; what a fascinating topic of discussion. You have my permission to speak your mind.

SGANARELLE: Well, sir, in that case, I must just say, that, frankly, no I don't approve of your carryings on sir; and I find all this loving everyone all over the place frankly objectionable.

DON JUAN: Really.

So you think one should shackle oneself to the first thing that catches one's eye; renounce the world, never look at another body again? Spend the rest of one's life mired in queasy marital self-congratulation; limit one's self to just the one passion, leave one's hunger for beauty behind with one's youth? I don't think so; fidelity is a career for fools. Just because one beauty happened to be the first one fell for is hardly reason to unfairly disadvantage all the others. I don't know about you, but I find beauty ravishing wherever and whenever I find it; what can one do but...submit? One gives one's heart, completely – ...just never so completely that one can't respond adequately to new opportunities as and when they arise: one's eyes, as one's mind, stay open. In such – and so many – circumstances, it would surely be churlish to say no; to deny oneself – and, more to the point, countless others – so; to each I give, according to

their merits; and from each, I take, according to my perfectly natural needs.

And besides, the novel has such inexplicable charm, don't you always find; one's greatest passion is always one's next.

Ah, the sweetness, the extreme sweetness of breaking down the defences of the as-yet inexperienced; of marking each day with a small yet significant advance; of battering away at that secret fear of surrender with a constant barrage of tears and well-timed rages; undermining all that petty, pointless resistance; of wearing down, step by expert step, all those morals they're always so proud of, inching them gently closer to exactly where you want them...but ah, – ah, then; the castle captured, there's nothing left to say; nowhere, now, to go: love's first fine rapture is...spent, and no pleasures await one but those of *familiarity* – unless, that is, some new object of the affections appears, to reawaken Desire, to inspire the slumbering Heart with dreams of conquests not yet made. Surely no prospect is as sweet as that of Triumph over Resistance; I approach that imperial task as any conquering hero would; always scenting the next victory, always surveying the next piece of uninvaded territory. No boundary can limit my eager desires; I want to make love to the entire Earth; and as Alexander did, I ache for undiscovered countries, for new worlds to ravish.

SGANARELLE: Goodness – not half bad with the speeches, are you sir? Anyone would think you'd learned all that off by heart from some play or other.

DON JUAN: The floor is yours. You were saying...?

SGANARELLE: I was saying...that I don't know what to say; you've got the knack of making it all sound like perfect sense, haven't you, sir; whereas obviously, it isn't, actually. Oh I was having some brilliant thoughts a

minute ago, but you've scrambled me all up now. Never mind, eh; next time I have them, I'll write them down, then when you fancy a bit of a discussion I'll be ready for you sir.

DON JUAN: I'm sure you will.

SGANARELLE: And when you do, Sir, that permission to speak my mind you mentioned, that will still cover me telling you I find this life you're leading a bit of a shocker?

DON JUAN: The life I'm leading. Do tell me what sort of life you imagine that to be.

SGANARELLE: A charmed one, sir. But, just a detail, this getting engaged to someone different every month and then leaving them –

DON JUAN: What could be more convenient?

SGANARELLE: Nothing; very convenient, I'm sure, and a source of great pleasure, I'm sure; I could go in for it myself, sir, if it wasn't, – well if marriage wasn't a sacrament of the holy church, sir –

DON JUAN: Thank you; that is a matter between myself and God, and one which we're perfectly capable of resolving without any help from you.

SGANARELLE: I'm sorry, Sir, it's just that I've always heard it said that mocking religion was in the worst possible taste, and that atheists always come to a bad end sir.

DON JUAN: Thank you! As I think I may have mentioned before, a sermon is not my idea of polite conversation

SGANARELLE: I wasn't referring to you, Sir! – Good Heavens above no; you know what you're doing, 'course you do, and if you're a non-believer I'm sure you've got your reasons sir – but you know there are some idiots

you meet these days, who *say* they're atheists without
ever having thought about it; who *pretend* to be
irreligious because so's everyone else these days; and I
tell you, 'if – *if* – if I worked for one of those, I'd say
straight out to him, straight to his face, I'd say; I don't
know how you've got the nerve to make jokes about
God like that; you, you want to watch yourself, taking
the piss out of religion. It's alright for you, you
miserable little insect, you little ant you, (this is my
imaginary master I'm talking to now) it's alright for you
enjoying yourself making a laughing stock out of all the
things that most ordinary people hold sacred, I suppose
you think that just because you're rich, just because
you're all dressed up with your (*Here SGANARELLE
specifies some details of DON JUAN's actual costume.*) – this
isn't you I'm talking to, sir; it's this other one – you
think, I'd say, you think that makes you better than
other people, that you can do anything you like, that no-
one will ever dare tell you a few home truths, don't
you? Well let me tell you, Sir, me, a member of your
staff, your humble servant sir, let me tell you, Heaven is
not mocked, Sir; the Wages of Sin, Sir, is –

DON JUAN: Ssssh…

SGANARELLE: What? What's the matter?

DON JUAN: The matter…is that I…have fallen. Again.

And the young person I've fallen for, is staying here.

Which is why, you may as well now know, we're here.

SGANARELLE: And may I ask, Sir, coming back here
again, this being where you killed that General just six
months ago, that doesn't worry you at all sir?

DON JUAN: Why should it? It was a duel. His death was
entirely proper.

SGANARELLE: Entirely; I can't think why he minded so
much.

DON JUAN: I thought it even had some style.

SGANARELLE: Yes, but I'm not sure his friends and family will be seeing style as the main issue; they might –

DON JUAN: Ah! Life is too short to worry about what *might* happen: the only thing one should ever imagine is Pleasure.

She's staying here with her fiancée; I happened to meet the two lovebirds three or four days ago, – and do you know, I don't think I'd ever seen such a perfect couple. So perfectly happy. I found the spectacle of their mutual bliss quite…moving; yes; I was quite struck. By jealousy, initially – and then by Spite; which aroused one, of course. One began to imagine the extreme pleasure one might derive from breaking up a partnership which, from the purely aesthetic point of view, one found so entirely offensive. But sadly all my efforts proved useless. Desperate measures were called for. So when I heard that her fiancée planned to bring her here to treat his intended to a romantic little expedition across the lagoon, I began making a few plans of my own. One small hired boat, one well-paid and unscrupulous crew, and I should soon have my hands on her.

SGANARELLE: Ha! Sir…

DON JUAN: Yes?

SGANARELLE: Marvellous; marvellous plan. What is the point of life, eh, if you don't always try and get what you want?

DON JUAN: I shall need you with me; make sure you pack the pistols, just in case the –

He sees DONA ELVIRA.

Ah. How inopportune.

And why didn't you tell me she was here?

SGANARELLE: You didn't ask sir.

DON JUAN: What on earth does she think she's doing appearing in public dressed like that?

Scene Three

DONA ELVIRA: Is it so shaming to acknowledge me, Don Juan? Would it be asking too much that you at least have the decency to look in my direction.

DON JUAN: Madam, you take me rather by surprise; I wasn't expecting you.

DONA ELVIRA: Yes I can see that. And clearly the surprise is not at all the pleasant one I had hoped it might be; the expression on your face is ample evidence that everything I've been telling myself couldn't possibly be true, is.

I think it's rather wonderful to have been as trusting as I've been. To have been so simple-minded as to have refused to believe I was being betrayed, when I had every evidence to the contrary. Of course I was always very good at that; at deluding myself; persuading myself to ignore the obvious; explaining away your sudden indifference towards me for instance; making your excuses for you. I must have invented at least a hundred different legitimate reasons why you'd left me over the last few days. I've been so plagued by anxieties you see; but I've kept on telling myself not to be so silly, not to listen to the voices whispering 'he's guilty', listening instead to a thousand beautiful romantic fantasies of your innocence. And now your welcome has shown me how stupid I was to doubt my fears; the look on your face when I walked into this room has taught me things I wish I'd never had to learn.

However, I would still love to hear you tell me why you left me.

Do say something, Don Juan, please; I'm sure you have an explanation prepared. And do make it amusing, won't you.

DON JUAN: Ask Sganarelle, he knows why I left.

SGANARELLE: Me sir? I don't know nothing about it.

DONA ELVIRA: And? Yes? Look I don't mind who tells me his reasons; just so long as someone does.

DON JUAN: (*Beckoning to SGANARELLE to approach.*) Go ahead; tell her.

SGANARELLE: What d'you want me to say?

DONA ELVIRA: Come here. Apparently he wants you do to the explaining; so; why did he leave me?

DON JUAN: Aren't you going to answer the lady?

SGANARELLE: It's not me who owes her an answer – and this is not my job.

DON JUAN: Answer her, I said.

SGANARELLE: Madam...

DON ELVIRA Yes?

SGANARELLE: (*Going back to his Master.*) Sir, –

DON JUAN: Yes –

SGANARELLE: Madam; we left, because of the conquering heroes; and Alexander; and all those countries he hasn't discovered yet.(*To DON JUAN.*) That's all I could remember sir, sorry.

DONA ELVIRA: Anything you'd perhaps care to add to that by way of clarification, Don Juan?

DON JUAN: Well to be brutally honest, ...Madam...

DONA ELVIRA: Ah! You obviously have no idea how a gentleman is expected to behave under these

circumstances – which is surprising, given your apparently extensive experience. It's pitiful – to watch you floundering… You might at least try and brazen it out. Try swearing that you feel for me as much as you ever did; that you still love me more than you've ever loved anybody in your whole life; that we will be together 'til death do us part! Or why not try telling me that it was a private matter of the utmost importance that obliged you to disappear without telling me you were going, that unfortunately it will occupy you for a few days yet and that it would probably be best if I went and waited patiently for you back where I belong, confident in the knowledge that you will be joining me again just as soon as you are able; that you ache for the time we will once again be alone together; that being apart from me causes you actual physical pain. I believe that's the usual form. Not standing there and saying nothing.

DON JUAN: I must confess, Madam, to having no talent for dissimulation; my heart never lies. How could I possibly tell you that my feelings towards you haven't changed, or that I (what was it?) *ache* for the time we will once again be alone together, when in fact, I left you simply in order to get away from you. And not for any of the reasons which you're probably imagining, but because I have a conscience; and it pricked me. It reminded me that to carry on living with you would have been a sin; made me look deep into my soul, Madam, and realise what I had actually done. That, in order to marry you, I'd plucked you from the sanctity of a cloister; made you break those solemn vows which made you a bride of Christ – and that God does tend to mind rather about that sort of thing. My soul was riven, and I stood trembling in fear of the Almighty. I knew then that our marriage would be adultery in all but name – and that I had to try and forget you; had to let you return to your first love. Who could withstand, Madam, such sacred promptings? If I'd have stayed with

you a day longer, Heaven might've completely lost its temper, and surely –

DONA ELVIRA: Ah! you wretch!! Now I understand what kind of man you are – too late; too late for the experience to teach me anything but how to despair. But know this, Don Juan; your crimes will not go unpunished; and Heaven, that same Heaven you make such mock of, will have its vengeance on you.

DON JUAN: Hear that, Sganarelle; Heaven!

SGANARELLE: I heard sir; Heaven eh…people like us, Madam, we don't believe in Heaven.

DON JUAN: Madam…

DONA ELVIRA: I should go. In fact I can't think why I've stood here this long and listened: I've always thought it rather a sign of weakness to wallow in one's humiliations.

Oh don't worry, I'm not going to scream at you or make a scene. No. No, I'm not going to waste my anger in words. I'll just say it again; Heaven will punish you, you monster, for what you've done to me; and if Heaven holds no terrors for you, then at least fear the fury of a woman scorned.

SGANARELLE: Well, if that doesn't get to him…

DON JUAN: (*After a moment's pause for reflection.*) We should go and make sure everything's ready for our next little amorous adventure.

SGANARELLE: Imagine working for a man like that, eh? Hell. Absolute Hell.

ACT TWO

Scene One

CHARLOTTE: God you got there just in time then.

PIERROT: Another minute and they could have both drowned.

CHARLOTTE: It was that bit of a gale this morning flipped them over was it.

PIERROT: I said to Lucas, that looks like people swimming to me, don't be silly he says, but I says no, stupid, look, there's two of them, they're waving at us; but they weren't waving, were they?; anyway, we gets the boat and gets them out and brings them back here, and then they took off all their clothes in the kitchen to get dried off, and that was when Mathurine turned up and he started staring at her, what's she like eh?

CHARLOTTE: The one that's much better looking than the other one?

PIERROT: The boss, yes. Tons of money. Mind you gentleman or no gentleman he'd still have drowned if I hadn't spotted them.

CHARLOTTE: Says you.

PIERROT: Bottom feeder, he'd have been. Crab bait.

CHARLOTTE: Still down there drying himself off is he. Still naked.

PIERROT: No... I said he was a gentleman didn't I. Got more than one set of clothes with him hasn't he. Got his man to bring down his black tie and cufflinks and fancy handkerchief and everything. Gentlemen and their clothes, I don't know.

CHARLOTTE: I wouldn't mind watching him getting all dressed.

PIERROT: Charlotte can I have a word.

CHARLOTTE: 'bout what?

PIERROT: Listen, Charlotte, the thing is, no listen, you know that I love you. There. I love you, and I think we should be getting married. But, I'm not happy. There.

CHARLOTTE: Why's that then?

PIERROT: Well you upset me sometimes, don't you.

CHARLOTTE: How do I do that then?

PIERROT: 'Cause you don't bloody love me.

CHARLOTTE: Oh not that again –

PIERROT: Yes that again –

CHARLOTTE: God always the same old bloody thing with you isn't it?

PIERROT: It's always the same old bloody thing with me because it's always the same old bloody thing with you, isn't it; and if it wasn't always the same old bloody thing with you then maybe it bloody wouldn't be bloody always the same old bloody thing from me, would it?

CAHRLOTTE Well what d'you want me to do about it, eh? What?

PIERROT: I want you to bloody love me don't I.

CHARLOTTE: Who says I don't love you.

PIERROT: You don't. And it's not like I don't try. I buy you things, don't I. It's not fair, not loving someone back when they love you.

CHARLOTTE: I do though.

PIERROT: Funny way you got of showing it.

CHARLOTTE: How d'you think I should be showing it then…

PIERROT: Properly.

CHARLOTTE: Are you saying I'm not proper?

PIERROT: All I'm saying is there's lots and lots of nice ways of showing somebody how much you love them and you don't. Look at that big fat Thomasina who's got a thing for young Robin; she's always running after him, never leaves him alone. The other day, he was sitting on this chair, and she pulled it out from under him, and he went flat out all over the carpet. That's the sort of thing people get up to all the time when they, when they love each other; but you, you don't never say nothing, you big log, I could be walking up and down the corridor a hundred times and you never so much as stop the dusting and give me a slap, never mind speak to me. And it's not on, Charlotte. You're too bloody cold-blooded for some people, I can tell you.

CHARLOTTE: Well that's not my problem is it. That's just human nature sometimes.

PIERROT: I don't care whose bloody nature it is, you got feelings, you want to find some way of showing them.

CHARLOTTE: I love you in my own way; and if you don't like it, well then you'll just have to go and love somebody else, won't you.

PIERROT: Oh, is that it then? That all I get?

CHARLOTTE: God you don't half go on you do.

PIERROT: All I'm doing, is asking you just to warm up a bit Charlotte.

CHARLOTTE: Well I'll tell you what, you stop pestering me, and you never know what might come over me one of these days.

PIERROT: Is that a promise?

CHARLOTTE: Might be.

PIERROT: Go on.

CHARLOTTE: Like I said; you never know... 'Course, it is supposed to just like happen, all of its own accord, you know – is that him?

PIERROT: Yes that's him.

CHARLOTTE: God, he's a bit of alright then. What a waste if that had drowned.

PIERROT: I'll see you later then. Got my break coming up haven't I.

Scene Two

DON JUAN: So, one badly timed squall, and even the best laid plans are scuppered. Not to mention the yacht. Still, that girl in the kitchen more than made up for it. Charming. A new acquisition, definitely – from the way the preliminaries went, I shouldn't think she'll take very long.

SGANARELLE: Great; we've just been nearly fatally shipwrecked, and is Sir offering heartfelt prayers for our deliverance, oh no, you're already working on your next f-f-frankly, you idiot, you don't know what you're talking about; the Master knows what he's doing; that will be all thank you.

DON JUAN: (*Noticing CHARLOTTE.*) Ah! – Sganarelle, have we seen this one before? Outstanding. I'd say she was at least as attractive as the last one, wouldn't you?

SGANARELLE: At least. Here we go again.

DON JUAN: Excuse me. And what on earth is a girl like you doing working in a place like this?

CHARLOTTE: Sir.

DON JUAN: You do work here?

CHARLOTTE: Yes Sir.

DON JUAN: And your name is?

CHARLOTTE: Charlotte Sir. And how may I help you?

DON JUAN: Did you know you've got the most remarkable eyes?

CHARLOTTE: Oh sir you're making me all embarrassed.

DON JUAN: Ah; one should never be embarrassed by the truth.

What do you think, Sganarelle. Pretty outstanding, eh? Turn around, would you. The figure's good. Head up, please…and the profile's charming. Eyes open wide. Splendid. And the teeth, please; ah – ah yes; charming. And what tempting lips you have. Well I don't know about you Sganarelle but personally, I'm bowled over.

CHARLOTTE: Very kind of you Sir I'm sure but you're having a laugh aren't you.

DON JUAN: Me? Laugh at you? God forbid. I'm far too attracted to you to find you amusing. In fact I've rarely been so serious.

CHARLOTTE: Thank you very much then.

DON JUAN: The beautiful should never be grateful.

CHARLOTTE: That's all a bit over my head sir. I don't know what you want me to say.

DON JUAN: Sganarelle, the hands. Look at her hands.

CHARLOTTE: God are they filthy or what.

DON JUAN: What do you mean – they're perfectly lovely; in fact, I'd like to kiss them. May I?

CHARLOTTE: I should think you'd like me to give them a good scrub first wouldn't you Sir.

DON JUAN: And tell me, Charlotte, I don't expect you're married, are you?

CHARLOTTE: No Sir but I am engaged.

DON JUAN: Don't tell me, to some dreadful fellow domestic. My God, what a waste. You, Charlotte, were not born to a life of drudgery; you were born for other pleasures entirely; and I think Heaven, realising as much, has brought me here for the express purpose of preventing this unfortunate union: in fact, you have only to say the word and I shall whisk you away from all this and set you up in the style to which you may not be accustomed but which you most certainly deserve. Now you may say this is all a bit sudden, Charlotte; but that's the effect you have on me; five minutes with you, and you've got me in the kind of state it normally takes me at least two weeks to work myself up into.

CHARLOTTE: You can't half talk, can't you. Sir. It all sounds lovely, and if I believed a word of it goodness knows where I'd be; but I was brought up not to, not coming from a gentleman. My auntie said you're all liars; gentlemen only ever want one thing from girls like me, she said.

DON JUAN: Gentlemen may; I don't.

SGANARELLE: Oh no he doesn't.

CHARLOTTE: You see sir, one mistake and a girl like me's had it. You have to be very careful, in my position.

DON JUAN: Do I look like the sort of man who takes advantage of people's positions? Do you really think I'd stoop that low? I am not entirely without principle, Charlotte; and, I love you: cross my heart and hope to die; and to prove I do, I promise, right here and right

now, to marry you. Whenever you want. What more do you want – I promise. Look, you've even got a witness.

SGANARELLE: Absolutely, don't you worry, he'll marry you as often as you could possibly want.

DON JUAN: Oh Charlotte, you don't know me; you think I'm like all the other men you've ever met, but believe me, that's a mistake; I know there are monsters out there, men who dream of taking advantage of girls like you, but please, I'm not one of them – when I say something, I mean it; trust me: and trust yourself. Trust your looks. When you're as beautiful as you are, what could there possibly be to be afraid of? Who would dare make a fool of a girl who looked like you? Myself, I'd rather cut myself open than even think of such a thing.

CHARLOTTE: God, I don't know if you're lying or not. But I hope you're not.

DON JUAN: Please do me the honour of trusting me, Charlotte. So, about my promise; my offer still stands. Will you marry me?

CHARLOTTE: Yes. If my auntie lets me.

DON JUAN: Give me your hand, Charlotte, and show me you mean it.

CHARLOTTE: You won't let me down sir, will you; that'd be a terrible thing on your conscience, when somebody'd trusted you like I'm trusting you.

DON JUAN: You still don't believe I mean it, do you?… What will it take?

As God is my witness –

CHARLOTTE: O God, don't; alright, I believe you.

DON JUAN: Then prove it by coming here and giving me a kiss.

CHARLOTTE: Oh, Sir, not until we're married. But when we are, married, I'll kiss you much as you want.

DON JUAN: Your wish is my command, Charlotte. How about your hand, then; just a hand to kiss, to kiss and let you know how ex-tra-or-din-ar-i-ly moved I –

Scene Three

PIERROT: (*Getting in between them and pushing DON JUAN.*) 'Scuse me Sir for breaking it up but I shouldn't like you to catch anything.

DON JUAN: (*Pushing PIERROT violently.*) Who let this in?

PIERROT: You can't go round kissing other people's fiancées. You keep off alright.

DON JUAN: (*Pushing him again.*) Did somebody say something?

PIERROT: Who d'you think you're bloody pushing?

CHARLOTTE: (*Holding PIERROT's arm.*) Leave it, –

PIERROT: No I bloody won't leave it!

DON JUAN: Ah.

PIERROT: What gives you the right to go round kissing our girls then. You want to stick to kissing your own bloody sort.

DON JUAN: What?

DON JUAN slaps him.

PIERROT: Don't you hit me (*Slapped again.*) Bloody hell (*Again.*) bloody Christ (*Again.*) bloody God, you don't want to go round hitting people you don't, specially when they're people what have saved you from drowning.

CHARLOTTE: Now don't get cross –

PIERROT: I am cross; and you, you want to be ashamed of yourself.

CHARLOTTE: Oh, you don't understand; he's not trying to…; he's going to marry me! So, there's no need for you to get angry.

PIERROT: What? You promised me – you said –

CHARLOTTE: Yes I know I did, but if you really love me, you ought to be happy for me, marrying money.

PIERROT: Yes well I'm not; I'd rather see you dead than married to him.

CHARLOTTE: Now don't get yourself in a state. When I'm set up with him, I'll make sure you do alright. Make him give you a job. Alright?

PIERROT: I wouldn't take wages from him if you paid me. Is that what he's been talking to you all about then, money? If I'd've bloody known I would have bashed him over the head with that oar not bloody pulled him out.

DON JUAN: (*Coming up to PIERROT to hit him.*) What did you say?

PIERROT: (*Moving behind CHARLOTTE.*) I'm not bloody afraid of you.

DON JUAN: (*Getting on his side of her.*) Stand still then.

PIERROT: (*Getting round the other side of CHARLOTTE.*) I'm not bloody afraid of anyone.

DON JUAN: (*Chasing him.*) Aren't you?

PIERROT: (*Dodging behind CHARLOTTE.*) You and whose army, eh?

DON JUAN: Ha!

SGANARELLE: Erm, Sir, let's leave it now shall we? I should hate you to do anything you might regret – and you, son, give it a rest eh – don't push him.

PIERROT: (*Pushing in front of SGANARELLE, and confronting DON JUAN.*) I'll push him far as I like.

DON JUAN: I think it's time you were taught a lesson.

DON JUAN raises his fist, PIERROT ducks and SGANARELLE nearly gets it.

SGANARELLE: (*To PIERROT.*) You sodding little idiot –

DON JUAN: If you will insist on interfering…

PIERROT: I'm going to tell your auntie what's going on, I am.

Exit PIERROT.

DON JUAN: Now where were we?

Ah yes, you were about to make me the happiest man in the world. Happier than if you gave me…all the tea in China. When you're my wife, we are going to have such –

Scene Four

SGANARELLE: (*Spotting MATHURINE.*) Ah. Ahem.

MATHURINE: Don't mind me. Just telling Charlotte you loved her as well, were you sir?

DON JUAN: (*Aside, to MATHURINE.*) No; actually *she* was just telling *me* how desperate she is to to marry me, and I was telling her that sadly I'm already engaged to you.

CHARLOTTE: (*To DON JUAN.*) What does she want?

DON JUAN: (*To CHARLOTTE.*) Me; but, as I've just explained to her, I'm already spoken for.

MATHURINE: Charlotte; –

DON JUAN: (*To MATHURINE.*) It's no use; she really does think she's going to marry me.

CHARLOTTE: (*To DON JUAN.*) Does she?
(*To MATHURINE.*) Yes?

DON JUAN: (*To CHARLOTTE.*) You may as well save your breath, she's completely convinced herself –

MATHURINE: Do you, –

DON JUAN: (*To MATHURINE.*) Though God knows I've tried to explain –

CHARLOTTE: Can I just say, –

DON JUAN: (*To CHARLOTTE.*) and dear God she's stubborn: –

MATHURINE: – seriously think, –

DON JUAN: (*To MATHURINE.*) but it's a complete waste of time; I actually think she's mad!

CHARLOTTE: – that I think –

DON JUAN: (*To CHARLOTTE.*) – and, she can be a bit hysterical; –

MATHURINE: Yes but it's only fair she knows.

CHARLOTTE: No, let her have her say.

MATHURINE: What?

DON JUAN: (*To MATHURINE.*) I bet she tells you I've promised to marry her.

CHARLOTTE: Just say that I…; well, –

DON JUAN: (*To CHARLOTTE.*) I bet she tells you we're engaged.

MATHURINE: Listen: Charlotte; trying to poach other people's property, well it's not very nice is it?

CHARLOTTE: And its not very ladylike, is it, Mathurine, getting jealous just because a gentleman wants a word with a fellow member of staff.

MATHURINE: The gentleman saw me first.

CHARLOTTE: And me second; after which, he promised to marry me.

DON JUAN: (*To MATHURINE.*) See?

MATHURINE: Excuse me, madam, but it's me he's promised to marry.

DON JUAN: (*To CHARLOTTE.*) What did I say?

CHARLOTTE: No, it's me, actually.

MATHURINE: No, actually, it's me.

CHARLOTTE: Go on then, why don't you ask him? He'll say it's me.

MATHURINE: I will; and he'll say its me.

CHARLOTTE: Right. Did you, Sir, promise to marry her?

DON JUAN: (*To CHARLOTTE.*) You are joking.

MATHURINE: Did you tell her you'd marry her? Sir?

DON JUAN: (*To MATHURINE.*) You're not serious?

CHARLOTTE: She claims you did.

DON JUAN: (*To CHARLOTTE.*) Well let her claim.

MATHURINE: She swears you did.

DON JUAN: (*To MATHURINE.*) I'm sure she does.

CHARLOTTE: I need to know –

CHARLOTTE: } what's going on

MATHURINE: } What's going on!!

CHARLOTTE: Exactly.

Sir… – this'll change your tune.

MATHURINE: I couldn't agree more.

CHARLOTTE: – If you wouldn't mind sir.

MATHURINE: – Then we can all get on. Sir.

CHARLOTTE: (*To MATHURINE.*) You'll see.

MATHURINE: (*To CHARLOTTE.*) Will I.

CHARLOTTE: Well?

MATHURINE: Sir?

DON JUAN: (*Embarrassed, speaking to them both.*) What can I say?

You both claim to be the girl I have promised to marry. But each of you, surely, already knows which one I'll choose, without me having to spell it out? What would further mere words from me achieve – surely, the lucky lady already knows, in her heart of hearts, who she is – knows I'll keep my promise. Doesn't she? The time for words is over; actions do, as they say, speak louder… And the minute I've married one of you, you can kiss and make up, because then, you'll both know who the person is who I really, truly, entirely love, won't you…so;

(*To MATHURINE.*) – Let her think what she likes

(*To CHARLOTTE.*) – Let her fantasize if she wants to

(*To MATHURINE.*) – I adore you

(*To CHARLOTTE.*) – Dream of you

(*To MATHURINE.*) – Have eyes for you only

(*To CHARLOTTE.*) – Want to spend the rest of my life with…you;

But
I have just remembered
A little urgent business
That requires my attention
Elsewhere
So if you'll excuse me, I shouldn't be more than fifteen
minutes.

CHARLOTTE: He loves me.

MATHURINE: Yes but he's going to marry me.

SGANARELLE: Ladies – ladies; you seem like nice girls,
both of you, and I can't just stand by and see you led
astray, can I now? Take it from me; listening to him
spin you a line may be fun, but you'd be better off
sticking to the day job. Eh?

You see, my master, he's an animal, to be honest with
you; give him an inch, and he'll take – well, let's just
say he's only after one thing, and believe me, he gets it,
gets it all over the place; promises to marry people
right left and centre, and then, when – (*He sees DON
JUAN returning.*) ...when you hear things like that said
about the man you work for, you have to speak up,
don't you;, you have to say, oh no he doesn't; he doesn't
promise to marry people right left or centre; animal, no
– he's after lots of things – and doesn't ever get any of
them, anywhere, ever, never has – oh good heavens,
here he is, he can tell you himself, go on, ask him.

DON JUAN: Yes, do.

SGANARELLE: As you know, Sir, the world is full of
gossip, these days, so I was just getting in there first and
telling them that if they heard any of that sort of thing
said about you they shouldn't believe a word of it, they
should come right out and say, that's a lie, that is.

DON JUAN: Sganarelle...

SGANARELLE: Because my master is a man of his word, believe you me.

DON JUAN: Hmnn.

SGANARELLE: Liars; dreadful people, dreadful.

Scene Five

STAFF: Excuse me Sir but I'm afraid I have to advise you to vacate the premises, immediately.

DON JUAN: I'm sorry?

STAFF: There are some gentlemen asking for you – twelve of them. I've no idea who told them you're here, but someone's obviously given them your description. They seem to be in a rather a hurry sir, and I got the distinct impression it might be wise if you left sooner rather than later.

DON JUAN: (*To CHARLOTTE and MATHURINE.*) Ladies; as I said, urgent business; but do remember my promises…you'll be hearing from me very soon. Tomorrow. Evening. At the absolute latest.

Scene Six

DON JUAN: Twelve of them. In which case, discretion is indeed the better part… Sganarelle, get your clothes off.

You dress as me, and I –

SGANARELLE: You are joking sir; if they think I'm you, they'll –

DON JUAN: Hurry up. It's not every day a servant gets the chance to demonstrate his loyalty by volunteering to die in his master's place.

SGANARELLE: Honoured I'm sure Sir.

Dear God, if it does come to anyone…dying…of a mistaken identity, you will make sure I get done for my sins, not his, won't you? Amen.

ACT THREE

Scene One

DON JUAN dressed roughly; SGANARELLE dressed as a Doctor.

SGANARELLE: No, go on, admit it Sir: this is much better; people would have still known it was us, you see – and now, *no-one will recognise us.*

DON JUAN: Where did you get that ridiculous outfit?

SGANARELLE: Do you mind, sir; I could get work, dressed like this. I've been consulted, I have.

DON JUAN: By whom?

SGANARELLE: Five or six of the local inhabitants have asked my professional advice already.

DON JUAN: You did tell them you were a charlatan?

SGANARELLE: Certainly not. I discussed their symptoms at some length, and prescribed where appropriate.

DON JUAN: Prescribed what?

SGANARELLE: Whatever came into my head. Well you never know what might work, do you – but I tell you what, if they recover, I shall charge.

DON JUAN: Why not? That seems to be the system with the rest of the medical profession. Mother Nature makes up her mind, and Doctors make up their fees.

SGANARELLE: So you're an atheist when it comes to medicine too, are you sir?

DON JUAN: Faith in medicine is as misplaced as faith in anything else.

SGANARELLE: So you don't believe in any of these new miracle drugs then?

DON JUAN: No. What makes you think I might?

SGANARELLE: You're a lost soul, you are. Convert anybody they would. I tell you what, I heard a fantastic case, happened three weeks ago.

DON JUAN: And.

SGANARELLE: There was this man, six days he's been dying, absolute agony it was; the doctors were in despair, so they gave him this new miracle drug.

DON JUAN: And he recovered.

SGANARELLE: No, he died.

DON JUAN: Astonishing.

SGANARELLE: Too right it was; six days he'd been trying to die – one treatment – worked straight away.

DON JUAN: Very good.

SGANARELLE: So, you don't believe in medicine; let us address another field of enquiry entirely, shall we?... – sorry sir, must be wearing a white coat, I feel very educated all of a sudden; just in the mood for another one of our friendly little philosophical discussions. You did say I could say anything I wanted – so long as it's not a sermon, obviously.

DON JUAN: Fire away.

SGANARELLE: Let us first address some questions of fundamental belief. Sir, is it really true you don't believe in God?

DON JUAN: Pass.

SGANARELLE: I'll take that as a No, shall I? Hell?

DON JUAN: Eh!

SGANARELLE: Not Hell either then. The Devil?

DON JUAN: Yes, yes.

SGANARELLE: Hmnn… Life after death?

DON JUAN: Ah, ah, ah.

SGANARELLE: I can see I'm going to have trouble getting to the bottom of this one. All right; Santa Claus. Do you believe in Santa Claus? Eh?

DON JUAN: No.

SGANARELLE: Oh now you're being ridiculous – everyone believes in Santa Claus. I mean. I mean everyone's got to believe in something. Haven't they.

DON JUAN: Have they?

SGANARELLE: Yes.

DON JUAN: I believe that two plus two makes four, Sganarelle, and that four plus four makes eight.

SGANARELLE: Oh very good. So what you believe in, is mathematics. Never mind religion eh, you've got Arithmetic. Which just goes to show, in my opinion, the better educated you are, the more stupid you end up; because you see me, Sir, I may not be as well-educated as you, thank God, in fact some people might say I'm living proof that ignorance is bliss, but let me tell you, with my native wit, my natural good sense, I understand things better than any book does; and I know, I know that this world of ours did not just spring up overnight all by itself. It is not a mushroom. I put it to you; the trees, the rocks, this earth beneath our feet, the over-arching sky above us; did they create themselves? – and you; you…standing there; you exist: and did you simply spring into being then; didn't your mother being got pregnant by your father have something to do with it? Can one consider that miraculous machine which is the human body, without being struck by…what a piece of work is man, how…well all the bits fit together…the

nerves, the bones, the veins, the arteries, the…the lungs, the heart, the liver, the other bits, in there, the way they all…oh come on, interrupt me for God's sake; it's very hard having a philosophical discussion all by yourself you know – …

DON JUAN: I was waiting for you to get to the point.

SGANARELLE: The point, the point, is…humans beings are amazing, and they do things – I don't care what you say – that no scientist can ever explain; for instance; here am I, standing here, and my brain is thinking a hundred different things all at the same time, getting my body to do anything it wants; now that, is a bloody miracle. 'Clap your Hands' – and I do; 'Wave your arms about'; 'Look Up'; 'Look Down'; 'Shake a leg'; to the right, to the left, in the front, round the back, in, out, in, out, shake it all about –

He spins and does a fall.

DON JUAN: It seems to me your argument hasn't left you with a leg to stand on.

SGANARELLE: Waste of bloody time arguing with you. You believe in what you want, see if I care if you go straight to hell.

DON JUAN: Meanwhile, our immortal souls aside, we do seem to have strayed from the straight and narrow; call that man over and ask him where we are.

SGANARELLE: Hello. Hello! Man; hello, me old china. Might I have a brief word?

Scene Two

SGANARELLE: We're lost. Could you possibly point us in the right direction?

THE POOR MAN: Just keep going straight on, gentlemen, and then turn right. But do be careful, won't you gentlemen, because we've had a lot of thieves round here lately.

DON JUAN: Thank you very much. We're most grateful.

THE POOR MAN: If you could see your way to helping me out, Sir...

DON JUAN: Oh, you charge, do you.

THE POOR MAN: Times is hard, Sir, God bless you Sir, I'll pray for you Sir.

DON JUAN: Why don't you pray for a new coat instead, and leave me out of it.

SGANARELLE: You're wasting your time with him, friend, he doesn't believe in anything except two and two making four – Oh, and four and four making eight.

THE POOR MAN: I pray day and night for the souls of all the good people who help me out sir.

DON JUAN: And how's business?

THE POOR MAN: Dreadful, Sir, haven't had two pennies to rub together all week.

DON JUAN: Surely not. A man who prays to God day and night and has nothing to show for it, that's ridiculous.

THE POOR MAN: Sometimes sir I don't even know where the next meal's coming from.

DON JUAN: How extraordinary. And how very unfair after all the effort you've put in. I tell you what; this, is a gold guinea. And I'm going to give it you. Right now.

But before I do, there's just one thing I want you to do for me. Blaspheme.

THE POOR MAN: Ah sir you wouldn't want me to commit a mortal sin now would you sir.

DON JUAN: All you have to do is decide whether you want a guinea or not. Look at it. No, no, no; blaspheme. Go on.

THE POOR MAN: Sir.

DON JUAN: No blasphemy, no guinea.

SGANARELLE: Go on…just blaspheme a bit; no-one will ever know.

DON JUAN: Take it. Go on. I said take it – And…

THE POOR MAN: No Sir, I'd rather go hungry.

DON JUAN: Oh go on, keep it, for the love of…for the love of our fellow men.

What on earth –

SGANARELLE: Looks like a fight sir –

DON JUAN: Three against one. Hardly my idea of fair. I can't possibly allow it.

He runs off to where the fight is happening.

Scene Three

SGANARELLE: You wouldn't think a man in his position would go looking for trouble…but when he feels strongly about something…oh, well; good lord; Don Juan to the rescue…

DON CARLOS: (*Entering from the fight.*) You can tell by the way those scoundrels are running what they think of your contribution to the fray. Can I just say how enormously I –

DON JUAN: (*From the fight, sword in hand.*) I'm sure you would have done the same; a gentleman does have certain obligations. And with that sort of low behaviour, if one is not actively against it, one is frankly for it. How on earth did you get involved?

DON CARLOS: For some reason my brother and the staff and I got split up, and when I tried to find them, I ran into that lot. D'you know I think they actually would have killed me if you hadn't appeared and put up such a good show.

DON JUAN: Are you heading into town?

DON CARLOS: Yes…my brother and I have got to sort out one of these ridiculous family honour affairs – which I think are the absolute bane of one's existence; it doesn't matter how decent one is, somebody insults one, and then of course one has to respond, and then the whole thing just escalates and takes over everything – and all because some idiot's made a fool of himself; still one is obliged to try and protect one's family name –

DON JUAN: Would it be wildly indiscreet of me to enquire as to the nature of this affair?

DON CARLOS: Well since it's hardly likely to stay a secret much longer, I may as well tell you; a man by the name of Don Juan Tenorio – Louis Tenorio's son? – seduced our sister – and eloped with her from her convent, would you mind. We heard this morning that he might be staying somewhere in this neck of the woods, but unfortunately so far we've had no luck finding out where exactly.

DON JUAN: And have you ever met him, this Don Juan?

DON CARLOS: Not personally, no, never seen him – but my brother has, and according to him he's an absolute –

DON JUAN: Can I stop you there? The man's a sort of friend of mine, and hearing you slander him would put me in a very difficult position.

DON CARLOS: Well sir, since it's you, and since he's your friend, and since after all you have just saved my life and it's frankly the least I can do, I shan't say a word; because any word I might say would be most definitely against him; but I do hope, sir, notwithstanding the man's being your friend, you won't, well, try and interfere in the business of those seeking legitimate redress.

DON JUAN: On the contrary, I'm eager to help; I am Don Juan's friend, there's not much I can do about that, but believe me, I'm as outraged as the next man at the thought of this kind of behaviour going unpunished. I'll personally see to it that he gives you satisfaction.

DON CARLOS: What sort of satisfaction?

DON JUAN: Whatever you require sir; and to save you any further time and trouble, you name the time and place, and I'll make sure he's there.

DON CARLOS: That would be most satisfactory sir.

I say I do hope we're not going to end up on different sides in this, after all I do owe you my life.

DON JUAN: If Don Juan is obliged to fight, I'm afraid I'm obliged too. That's how close we are; in fact in a situation like this I feel I can speak for him; so name your place and time sir; he'll be there, and you'll get your satisfaction.

DON CARLOS: Oh this is dreadful –

Scene Four

Enter DON ALONSE, his staff.

DON ALONSE: Find me later will you; I'm going to stretch my legs for a bit – what the – what are you doing talking to him, Carlos?

DON CARLOS: Talking to who?

DON JUAN: (*Stepping back three paces and proudly resting his hand on the hilt of his sword.*) To me. Yes that's right; Don Juan himself. I may be outnumbered, but I see no good reason to also be anonymous.

DON ALONSE: Say your prayers, you –

DON CARLOS: Wait! – he saved my life: I ran into a bunch of robbers, and if he hadn't intervened, they would have killed me –

DON ALONSE: If you don't want to be involved, all you have to do is step aside, I'll be perfectly happy to do this by myself.

DON CARLOS: and in consideration of that fact, I think we should –

DON ALONSE: He has to die.

DON CARLOS: Wait. Brother; I owe this man a debt of honour, and by God if anyone, even you, raises a rash hand against him, I shall intervene, even at the risk of my own life, believing as I do that *noblesse* does indeed *oblige.*

DON ALONSE: What?

DON CARLOS: I mean are we gentlemen or are we beasts?

DON ALONSE: What a bizarrely old-fashioned sense of what constitutes gentlemanly behaviour you have sometimes.

DON CARLOS: I'm just saying we need to do this properly. And not lose our tempers. Brother.

Don Juan, as you can see, I am going to considerable personal lengths to repay your assistance in kind. Rest assured that I shall in due course prosecute our vengeance with equal diligence. I shan't ask you to explain why you did what you did to our sister – you know the enormity of your offense; I leave you, as a fellow gentleman, to decide on the appropriate reparation. There is of course an amicable solution to this situation; or, there is a violent one. Whichever you choose, do remember that you've given me your word. You promised me I should have satisfaction from Don Juan, and if the time comes for me to take it, then I shall. Take it. Fully.

DON JUAN: I wouldn't have it any other way: and I always keep my word, sir.

DON CARLOS: Shall we go, brother?

DON ALONSE: Sir.

Scene Five

DON JUAN: Oi!! Sganarelle!!

SGANARELLE: Did you call?

DON JUAN: So I'm attacked, and you run away.

SGANARELLE: Sorry sir I just had to pay a brief visit; must be this medical outfit, it's had a very laxative effect on me.

DON JUAN: Please! If you must be a coward, try not to be a vulgar one.

You do realise who that was whose life I just saved?

SGANARELLE: Me? No.

DON JUAN: One of Dona Elvira's brothers.

SGANARELLE: One of –

DON JUAN: He's quite a striking young man actually, handles himself rather well. I'll be sorry to have to tangle with him.

SGANARELLE: There is a much easier way you could sort this all out.

DON JUAN: There is; but, unfortunately, my feelings for Dona Elvira are over.

Keeping promises never was my strong suit.

I need to love freely, you know that; I could never be happy with four walls round me. You've heard it twenty times, but I'll say it again; the only obligation I recognise is to my own desires. I belong to all the women in the world; if they want me, they can have me; one by one by one by one…but they can't keep me.

Sganarelle, what is that rather imposing building doing out here amongst all these trees?

SGANARELLE: That? Don't you know, sir?

DON JUAN: No, I don't.

SGANARELLE: Oh…right; that's the tomb the General was in the middle of having built for himself when you killed him.

DON JUAN: I see. How odd, I had no idea that was near here. Apparently it's extraordinary inside, especially his statue. I've always wanted to see it.

SGANARELLE: Sir, don't go in there.

DON JUAN: Why not?

SGANARELLE: Well its hardly polite is it paying a call on a man you've killed.

DON JUAN: Actually it strikes me as the height of good breeding. I'm sure he'll be perfectly civil; we're both gentlemen after all.

Come on, let's go inside.

The tomb opens, and the audience sees a superb mausoleum and the STATUE of the Commander.

SGANARELLE: Amazing! Look at those amazing statues! And all that amazing marble! All this amazing plasterwork! Cor! Don't you think it's amazing sir?

DON JUAN: What amazes me is the vanity of the dead: how extraordinary that a man who prided himself on the good taste of his interiors when he was alive should have wanted something this grandiose to rot in.

SGANARELLE: That'll be his statue then.

DON JUAN: Who does he think he is? Julius Caesar?

SGANARELLE: Incredible isn't it sir. You'd almost think he was alive, and just about to say something – oh, I'm glad I'm not in here on my own. He doesn't look very pleased to see us, does he.

DON JUAN: He ought to be, we've come all this way. Ask him if he'd like to come and have dinner with me.

SGANARELLE: I don't think they eat much where he is.

DON JUAN: Ask him!

SGANARELLE: You're joking. I can't go round talking to statues, people'll think I'm mad.

DON JUAN: Please do what I tell you.

SGANARELLE: – oh this is ridiculous!… Dear Sir, General… – no but you've got to laugh, haven't you, the things he makes me do, eh? – …General, Sir, my master Don Juan has asked me to ask you if you would do him the honour of coming and dining with him.

The STATUE nods its head

Ha!

DON JUAN: What? What's the matter with you? Well say something! Speak.

SGANARELLE: (*Making a sign like the statue did, and nodding his head.*) The Statue...

DON JUAN: What? What are you trying to say, idiot?

SGANARELLE: I'm trying to tell you that the statue...

DON JUAN: The statue what? If you don't say something, I'll –

SGANARELLE: ...nodded at me.

DON JUAN: Damn you –

SGANARELLE: I'm telling you it nodded at me, God's honest. Don't believe me, you have a go. Maybe it –

DON JUAN: Oh come here you snivelling little coward – come here. Ready? Your Excellency, would you care to join me for dinner?

SGANARELLE: Bet you ten quid it nods.

The STATUE nods its head again.

Ha!
Sir?

DON JUAN: Right, let's get out of here shall we.

SGANARELLE: Clever, some people. Don't believe in anything.

ACT FOUR

Scene One

DON JUAN: ...whatever it was, leave it: it doesn't matter. It was probably a trick of the light. Some sort of optical hallucination.

SGANARELLE: Ah, Sir, we both saw it, plain as day. If you ask me, it's perfectly obvious why it nodded its head; God, tired of your wicked ways, has sent you a miracle, to convert you, and save you at the very last minute from the pains of –

DON JUAN: Listen. If you continue to pester me with any more of this half-baked sermonising, if you say just one word more, I shall equip myself with a bullwhip, pay three of the staff here to hold you down, and thrash you to within an inch of your life. Do I make myself quite clear?

SGANARELLE: Absolutely sir, but then that's what they always say about you, goes straight to the point Don Juan, never beats about the bush, lucidity itself.

DON JUAN: Good. And would somebody please tell the kitchen I want dinner *tonight*. If that's possible.

Scene Two

STAFF: Sir, there's a gentleman asking to see you, says you owe him some money? A Mr Sunday?

SGANARELLE: Oh that's all we need, a creditor. Who do they think they are eh, expecting to get paid – say he's out.

STAFF: I've been saying that for the last three quarters of an hour, but he doesn't believe me, and says he'll wait.

SGANARELLE: He can wait as long as he likes; –

DON JUAN: No, no, let him in; one should always confront creditors . The trick is, to never give them anything, while making them feel you have given your all.

Scene Three

DON JUAN: (*With exaggerated civility.*) Mr Sunday! – come in…I'm so pleased to see you – and so sorry – no-one told me – I'm not officially here you see – but since it's you; well –

MR SUNDAY: Thank you very much sir.

DON JUAN: (*To his staff.*) How dare you make Mr Sunday wait. Have you no idea who this *is*?

MR SUNDAY: Really Sir, I was only waiting –

DON JUAN: Mr Sunday; one of my very closest acquaintances?

MR SUNDAY: Thank you sir. Now –

DON JUAN: Do sit down.

MR SUNDAY: I'm quite comfortable thank you sir. Now –

DON JUAN: No I insist you sit down –

MR SUNDAY: I'm quite happy to –

DON JUAN: No, no, please; you're an honoured guest, Mr Sunday.

MR SUNDAY: Sir –

DON JUAN: Do sit down.

MR SUNDAY: I am quite happy standing thank you, this won't take a moment. Sir, I –

DON JUAN: I shan't listen unless you sit down.

MR SUNDAY: If you insist, sir.

I –

DON JUAN: Goodness you're looking well, Mr Sunday.

MR SUNDAY: Thank you sir. I have come here tonight –

DON JUAN: The very picture of health.

MR SUNDAY: Here, tonight, in order to –

DON JUAN: And how is Mrs Sunday?

MR SUNDAY: Very well, thank you sir.

DON JUAN: Do give her my regards, won't you.

MR SUNDAY: I shall, sir, thank you. Come here –

DON JUAN: And your little girl – Claudine; how is she?

MR SUNDAY: As well as can be expected.

DON JUAN: Charming girl! I'm terribly fond of her you know.

MR SUNDAY: Very kind of you I'm sure sir. Here, tonight, –

DON JUAN: And little Colin; still bashing away at that terrible tin drum of his, is he?

MR SUNDAY: Yes, Sir, he is. Tonight, in order –

DON JUAN: And what about your little dog – …

MR SUNDAY: Brisket –

DON JUAN: Brisket, still a bit of an ankle-biter, is he?

MR SUNDAY: Worse than ever sir, can't do a thing with him.

DON JUAN: Forgive me for asking, but I am terribly fond of them all, as you know.

MR SUNDAY: You're very kind sir I'm sure. I have –

DON JUAN: (*Taking hold of his hand.*) Mr Sunday; d'you know, you really are one of my best friends.

MR SUNDAY: At your service, sir.

DON JUAN: One of my absolutely closest friends.

MR SUNDAY: Thank you very much sir. I –

DON JUAN: There's nothing I wouldn't do for you.

MR SUNDAY: You're really too kind sir.

DON JUAN: I genuinely like you, you see.

MR SUNDAY: Well that's very kind of you sir but I'm only –

DON JUAN: Only nothing – Mr Sunday, would you stay and have dinner with me?

MR SUNDAY: No really sir I must get back: I –

DON JUAN: (*Getting up.*) Really? Can you find your own way out Mr Sunday or would you like somebody to see you down?

MR SUNDAY: (*Also getting up.*) I'm sure I can manage sir. But if I –

SGANARELLE whips away the chairs.

DON JUAN: Someone had better go with you; I should hate anything to happen to you on the way down – sorry to fuss, but I don't just owe you money you know, I care about you –

MR SUNDAY: Yes about that, sir –

DON JUAN: And I don't mind who knows it.

MR SUNDAY: I –

DON JUAN: Of course, I could come with you myself –

MR SUNDAY: No please don't put yourself to any trouble. Sir –

DON JUAN: Goodbye then; and just remember; if there's ever anything I can do for you, anything you ever want from me, my dear old friend, then please, please, please; just ask. (*He leaves.*)

SGANARELLE: I think he really does like you.

MR SUNDAY: Well he certainly says he does…says it so often we never got round to talking about my money.

SGANARELLE: But then we both do; honestly, if something was to happen to you, – say for instance…say someone tried to beat you up on the way home; we'd be there, we'd be…

MR SUNDAY: I'm sure you would: do you think you might mention the money to him.

SGANARELLE: Don't you worry. He'll pay up.

MR SUNDAY: And about that little outstanding bill of yours –

SGANARELLE: Ah! Please don't start.

MR SUNDAY: I beg your pardon? I –

SGANARELLE: I am aware that I have debts, actually.

MR SUNDAY: Well I'm sure you –

SGANARELLE: This way, Mr Sunday.

MR SUNDAY: But what about my money!

SGANARELLE: (*Taking hold of him by the arm.*) You are joking!

MR SUNDAY: I really –

SGANARELLE: (*Pulling him.*) Yes?

MR SUNDAY: Look, I've heard –

SGANARELLE: (*Pushing him.*) Rumours –

MR SUNDAY: But –

SGANARELLE: (*Pushing him.*) Off!

MR SUNDAY: I –

SGANARELLE: Off, I said. (*Pushing him suddenly right off the stage.*)

God! Honestly!

Scene Four

STAFF: Sir there's a gentleman asking to see you – your Father.

DON JUAN: Oh good. Just the person I need to perfect my evening.

DON LOUIS: Does the mere sight of me embarrass you so much?

You'd probably rather I hadn't come – well believe me, I'd rather I hadn't had to; you may be weary of the sight of me sir, but not as weary as I am of the reports I receive of your behaviour.

My God, what fools we are, when instead of trusting Heaven to know what is best for us we insist on knowing better; start pestering it with our importunate demands, with ill-considered desires. No-one ever wished for a son as devoutly as I did; I went down on my knees every night and begged for one; wearied Heaven with my relentless prayers: and see how they were answered. With a son who has blighted the very old age I intended he should support.

How should a father respond, would you advise, sir, to these spreading rumours – rumours so shabby I am increasingly hard put to explain them away; to this

ever-lengthening list of scandals for which I must beg other people's pardons until I have all but exhausted the credit of our hitherto respected name. Ah, the depths to which you have dragged it! Are you not ashamed sir? Ashamed to still bear it? What have you ever done to earn the right to be called a gentleman? Did you think it was simply a matter of one's birth? Did it never occur to you it might concern the manner of one's life? No sir; rank is nothing, without at least decency. A man has no right to claim his family's privileges unless he shares its values! If my father, and his, and his, could speak, far from acknowledging you theirs, they would disown you; for far from reflecting any glory on you, their illustrious reputations do nothing but shed a battery of bright and rather damning lights on the depths to which you have now sunk us. I tell you, a man who lives as you do is no gentleman, sir; that distinction is a reward, not a right; that a good name counts for nothing, without a good life lived; and that I, sir, I would rather acknowledge a labourer, a common labourer, as my son, if he knew how to conduct himself, than a prince of the blood royal with a reputation like yours.

DON JUAN: If this is going to be a long speech you might want to sit down.

DON LOUIS: I will not sit down, sir; and I will not waste another word on your evidently hardened heart; but you listen to me; a father's love has its limits, and you have driven me beyond them: if there is a way to cut short your infamous career, I shall find it; and sooner than you think. Perhaps, if I forestall the wrath of Heaven by punishing you myself, I may even wash away some of the shame I feel at having fathered you. (*He leaves.*)

Scene Five

DON JUAN: Oh die, why don't you: and soon. Every dog has his day, and yours is over. I do hate it when fathers with grown-up sons…hang on.

He sits down in his chair.

SGANARELLE: Sir, that was wrong.

DON JUAN: Wrong?

SGANARELLE: Sir.

DON JUAN: (*Rising from his chair.*) Wrong?

SGANARELLE: Yes sir, it was wrong…of you to let him talk to you like that. You should have slung him straight out. I've never heard anything like it; a father lecturing his son, telling him to mend his ways, remember he's a gentleman and try and act like one for a change, all that sort of old-fashioned nonsense. I'm surprised you stood for it, a man like you, a man of the world. You're more tolerant than me, I can tell you, I'd have told him to sling his hook straightaway sir.

O, the humble servant; are there no depths to which he will not stoop, eh?

DON JUAN: Are they *ever* going to serve dinner?

Scene Six

STAFF: Sir there's a lady asking to see you, says she must talk to you. She's wearing a veil?

DON JUAN: A veil? Which one's that then?

SGANARELLE: One way to find out…

DONA ELVIRA, dressed for her return to the convent.

DONA ELVIRA: Please don't be surprised, Don Juan, to see me at this late hour and in these clothes again. The reasons for my visit are pressing ones; I have things to say to you that can't wait.

I am a very different woman from the one who visited you this morning; the rage that swept through me then

is spent. This is no longer that same Dona Elvira who breathed fire at you; whose heart held nothing but hate for you; whose only dreams were of vengeance. Heaven has driven from my breast all the undignified passions I once felt for you; all the secret dreams of another life; all the shaming lusts, all physical desire. It has burnt away all grossness from my heart, leaving only a holy, sanctified affection; a tenderness without stain; a love that desires nothing, that asks for nothing in return, that seeks nothing but your safety.

DON JUAN: (*To SGANARELLE*.) You're crying, aren't you?

SGANARELLE: Sorry.

DONA ELVIRA: It is this pure and perfect love that has brought me back here, to bring you the word of God; to offer you one last hope, though you stand poised on the brink of damnation. Yes, Don Juan; I know the filthy life you lead, and yet believe me, that same God who has touched my heart and awoken my conscience, who has made me see the error of my disordered ways, has led me here to you, to tell you, from Him, that though your sins have tested even His divine patience to the limit, though His holy anger is poised above your head even now, though you may have no more than this one last night to avoid the most terrible of all fates, yet you may avoid it by a prompt repentance. For myself, I have no feelings left for you now. With God's help, I have renounced all my mad disordered thoughts, and have decided to return to my convent, where I shall ask nothing more of Him than that He grant me days enough in which to repent the error of my ways, and to earn through strict penance His pardon for the blindness into which my sinful passions once plunged me: but even in my withdrawal from the world I shall I think still be capable of feeling great unhappiness should I hear that any person for whom I once cared, so greatly, had become a terrible example of His justice; and, likewise, of feeling great joy to know I had turned aside

from his head the terrible blow which now hangs over it.

I beseech you, Don Juan, grant me that consolation as my last request. Do not refuse Salvation. I beg this of you with tears in my eyes, and if your own plight cannot move you, at least let mine; spare me the horror of seeing you condemned to eternal torment.

SGANARELLE: Poor woman.

DONA ELVIRA: I loved you with all my heart; nothing in the world meant as much to me as you did; I broke my vows for you. I did everything you asked; and the only thing I ask of you in return, is that you mend your ways, and save yourself.

Save yourself, I beg you; in the name of whatever it is that can still move you. If you don't love me, you must at least love yourself.

SGANARELLE: Heart of Stone.

DONA ELVIRA: That's all I had to say. I'll go now.

DON JUAN: Madam, it's late, why don't you stay. I'm sure they could find you a room.

DONA ELVIRA: No; please don't try and stop me leaving.

DON JUAN: It would give me the greatest of pleasure if you would stay, really it would.

DONA ELVIRA: I said no: don't waste what time you have left on me, Don Juan; let me go; and please don't offer to see me out; I just wanted to warn you, that's all.

Scene Seven

DON JUAN: D'you know I think I actually felt something then? There was something rather novel and rather...moving about the whole thing – the slightly dishevelled clothing; the distressed expression; the tears.

And there was I thinking that particular fire was completely out.

SGANARELLE: In other words what she actually said went straight in one ear and –

DON JUAN: Dinner, now.

SGANARELLE: Absolutely.

DON JUAN: Sganarelle –

SGANARELLE: Sir?

DON JUAN: (*Sitting down to eat.*) I shall have to think about how I live my life eventually.

SGANARELLE: You certainly shall.

DON JUAN: Yes – God yes; a New Life. Another twenty or thirty years of this one, and we'll definitely have to think about it.

SGANARELLE: Oh.

DON JUAN: What?

SGANARELLE: Nothing; Dinner is served.

SGANARELLE steals a titbit from one of the plates and puts it in his mouth.

DON JUAN: You look as though you're suffering from a toothache.

SGANARELLE: (No I'm fine.)

DON JUAN: What is it then?

SGANARELLE: (Nothing.)

DON JUAN: Speak up, what's the matter with you?

SGANARELLE: (Nothing.)

DON JUAN: Let me look; oh, nasty; definitely an infection – I shall have to lance that. Scalpel! The poor boy can't

stand the pain…you could choke on an abscess like that…look at the size of it… Ah! All better now?

SGANARELLE: I was just checking the seasoning. Honestly.

DON JUAN: Oh sit down shut up and eat something. And when you've finished, I've a little job for you. Hungry, I see.

SGANARELLE: (*Sits down to eat.*) Well surprise surprise, we haven't stopped since breakfast…you should try some of this, its delicious – (*STAFF remove his plates as soon as he puts food on them.*) 'Ere, slow down, that's my plate. If you don't mind. And would it be too much trouble… (*One takes his plate away while another pours him a drink.*) One can't get the staff these days.

DON JUAN: Here's a knocking indeed.

SGANARELLE: Who the hell – don't people know it's dinner time?

DON JUAN: Can a man not even eat in peace? – I'm not here.

SGANARELLE: Certainly Sir – no no don't get up…

DON JUAN: What? Who is it?

SGANARELLE nods his head like the STATUE did.

SGANARELLE: It's the…the …'s here.

DON JUAN: Well why don't you show him in. Do I look as if I'm easily scared?

SGANARELLE: Oh Sganarelle, no peace for the wicked.

Scene Eight

The STATUE goes to seat itself at the table.

DON JUAN: A chair for our guest. Quickly!

(*To SGANARELLE.*) And do join us.

SGANARELLE: I'm not really hungry thank you sir.

DON JUAN: I said join us! Pour the wine. Pour our guest a glass too. A toast, Sganarelle; Good Health. Long Life.

SGANARELLE: Or thirsty sir.

DON JUAN: Drink! And now perhaps our guest would enjoy a little song.

SGANARELLE: I've got this dreadful cold sir –

DON JUAN: Never mind, let's have some music.

THE STATUE: Don Juan: enough. Perhaps tomorrow you might join me for dinner at my house.

DON JUAN: Tomorrow?

THE STATUE: Or would that scare you.

DON JUAN: Not at all. I shall come on my own. With Sganarelle.

SGANARELLE: That's very kind Sir but I was planning to fast tomorrow night for religious reasons.

DON JUAN: Please show our guest out. Would somebody turn on the lights!

THE STATUE: One has no need of light, when Heaven shows the way.

ACT FIVE

Scene One

DON LOUIS: My dear boy. Thank God. Is it true?

DON JUAN: Yes. I have seen the error of my ways. I am not the man I was last night; the Lord has wrought a miracle in me. He has touched my heart; the scales have fallen from my eyes, and behold, I look with horror on the darkness in which I once dwelt, on the foul abominations of the life I once led. When I consider how that life was spent, I marvel that Heaven has withheld its justice for so long, when twenty times its righteous thunders might have fallen on my deserving head. I thank God in His mercy that He has seen fit not to punish me for my crimes, and, in gratitude for His grace abounding, I intend to make, by full and frank and public confession, what amends I can for the scandalous example of my past life, trusting always in the Divine Mercy to grant me what final forgiveness it sees fit. A new life, that is what I want!! – and Father, I need your help to achieve it. Tell me, to whom shall I turn to confess? Who shall I choose to set my footsteps on the paths of righteousness?

DON LOUIS: Oh, my son, how swiftly a father can forgive; how many sins be erased by one word of remorse. So many times you have hurt me; but already, well, after a speech like that – they're forgotten; forgotten, quite. I can hardly believe it…or contain these foolish tears of joy. …God how I prayed, prayed so often, and so hard…and now…come here. My son. Be steadfast – steadfast, sir – in your resolution. I shall go and give our good news to your mother, share my happiness with her – as I always do. And thank God. Thank God.

Scene Two

SGANARELLE: Phew! So, Sir...so you've seen the light at last! God knows its been a long time coming, – years I've been praying for this, sir, years – and now, hey presto – well, Praise The Lord, that's what I say.

DON JUAN: Idiot. You idiot.

SGANARELLE: What'd'you mean, idiot?

DON JUAN: What? You believed *that*? You thought I *meant what I said*?

SGANARELLE: You mean you – you didn't – you haven't – oh!

Oh, what a one, eh? What a man! What a man.

DON JUAN: No, I didn't; and no, I haven't. Either my life or my mind.

SGANARELLE: So that whole miraculous walking talking statue bit, that hasn't given you pause for thought at all?

DON JUAN: I'll admit that was a bit odd; but just because something isn't immediately explicable doesn't mean it's going to either terrify me out of my wits or shake my convictions; and just because I start promising to reform, start describing my new and exemplary life –; tactics; a purely political posture, adopted, temporarily, to maintain my control over my Father – which I do need to maintain: and to provide me with some much-needed public cover during my current, and legion, difficulties.

And why would I need a confessor, when I already have you? Already have someone who knows everything about me...knows the real reasons why I do the things I do.

SGANARELLE: What? You don't believe in anything, anything at all, and so now, you plan to set yourself up as a man of religious principle.

DON JUAN: And why not? One can think of several prominent people who've made it their entire career.

SGANARELLE: As I said before, what a man.

DON JUAN: There's no shame in hypocrisy, nowadays; it's the most fashionable of vices – so fashionable most people think it's a virtue. The man of principle is a deservedly popular role at the moment; if a little hypocrisy's required...well. It's an art that commands genuine respect; the deception that everyone recognises, but no-one dares condemn. We live in a censorious and disapproving age; everyone feels free to denounce everyone else at will – but Hypocrisy, Hypocrisy has friends in high places; it has special privileges; one wave of its hand, and the world is hushed; it is...unimpeachable. All Hypocrites naturally agree; their lies make them collaborators – challenge one, and you'll have the lot on your back – and meanwhile, the good people, the people who everybody knows are still genuinely good, the...sincere: the Sincere are always the Hypocrite's easiest prey; they are so gullible; they fall for our act hook line and sinker. When we parrot their language, they ape us. Look around you; misspent youth caught up on you my friend? – confess, and everyone will agree that you have an absolute right to carry on practising the worst of your vices however you see fit. A little penitence, carefully applied, is the best possible cover; of course, everyone will know exactly what you're up to, will know exactly what sort of a person you actually are; but no-one will think any less of you. A catch in the voice, a remorse-furrowed forehead, an imminent tear in the meekly downcast eye; all will be forgiven.

It'll buy me the time to set my affairs in order. I shan't give up any of my...pleasures; I shall just be a little more careful. A little more discreet. And if I get caught, I shall simply stand back and let my fellow Hypocrites make my apologies for me; to everyone and for

everything. In fact, as a paid-up Hypocrite, I shall be free to get away with whatever I choose. I rather fancy life as a moral arbiter; I shall sit in judgement on other people's lives – and condemn everybody's except my own. The slightest infraction – a *hint* of impropriety – and I shall be implacable: utterly unforgiving: firmly, but gently, I shall preach hate. God, you see, will be on my side, and armed with that most flexible of alibis, I shall pursue my opponents; publicly denounce them; unleash on them all the forces of bigotry; every self-appointed censor who wants to scream from the rooftops the vicious tenets of his own invincible personal moral authority.

Where there is weakness, I shall find opportunity. It is after all the duty of intelligence to thrive on the vices of its own particular century.

SGANARELLE: O, my, God. The finishing touch. Seven sins just weren't enough for you were they, you had to add Hypocrisy to the list. Right. Sir; that, was the last straw; hit me, slap me, stab me, sack me, but I'm going to have to speak my mind now; in fact, I feel I would be failing in my duty as a good and faithful servant were I not to.

Sir, take a pitcher to the well one too many times, and eventually, it'll crack: and, as whatsisname puts it, so forcefully, a Man, in the midst of this life, is perched no more securely than a bird on a branch; and that branch is of course part of the whole tree; and a branch in time saves nine; and wood is thicker than water; fine words butter no parsnips, and there is no such thing as Society! Society is rarely, if ever, Polite; but; Manners Maketh Man; Man shall not by bread alone live his life; which ends in Death; which is life's way of reminding you of Heaven, our father which art in; that Heaven, which is not of this Earth; that Earth, which is not the Sea; the Sea – where you get Storms; Storms which sink Ships; and Ships need Pilots; Pilots need to be careful; but so often young people aren't; they don't obey their olders

and betters; who are better because they're *richer*; money makes you rich; the rich are never poor; while the poor, lack the necessary; and necessity knows no law; and if there's no laws, then we may as well all just give up and live like pigs anyway; and so, in conclusion, you see, you, Sir, will be damned. Damned.

DON JUAN: O I do see. So much more clearly now.

SGANARELLE: Well you can't say you haven't been warned.

Scene Three

DON CARLOS: Don Juan; how convenient to find you still here. Have you come to any decision?

Look, we'd much rather we resolved this whole thing amicably. All that we're asking is that you publicly acknowledge our sister as your wife.

DON JUAN: (*As if he was a hypocrite.*) Alas, if only life were that simple; if only I could give you the satisfaction you require; but the Lord has spoken; and he has suggested a change of heart. I long for nothing now but to leave all earthly vanities behind me, to renounce all merely fleshly attachments; to do penance for the foul errors of a youth misspent in the byways and back alleys of sin by adopting a new and entirely chaste way of life.

DON CARLOS: Such a welcome change of heart, Don Juan, would hardly conflict with what we're proposing. The companionship of a lawful wife would surely be entirely in keeping with what the Lord has suggested.

DON JUAN: Sadly, again, alas; the Lord has also suggested much the same thing to your sister. She has vowed to retire once again to her convent. We received the call simultaneously.

DON CARLOS: I'm afraid that won't solve our problem; people will assume her retirement is prompted by shame

– shame for what you've done to her and to my family. A family whose honour requires she lives with you.

DON JUAN: Oh would that she could; d'you know, earlier this very morning I was down on my knees and praying to God for that very thing; but as soon as I mentioned it, I heard a voice saying unto me to forget all about her – that as long as I stayed with your sister I could never hope for salvation.

DON CARLOS: Don Juan do you really think –

DON JUAN: The Lord has spoken.

DON CARLOS: D'you really think I'm going to be fobbed off with this religiose idiocy?

DON JUAN: If the Lord wants you to be, yes.

DON CARLOS: My sister left her convent for you –

DON JUAN: The Lord moves in mysterious ways.

DON CARLOS: – and do you now expect my family to simply stand by and watch her trampled underfoot?

DON JUAN: Why don't you ask the Lord.

DON CARLOS: Christ!

DON JUAN: Exactly.

DON CARLOS: Enough; I see through you. This is neither the time nor the place; but believe me, when I'm ready, I'll find you.

DON JUAN: As you wish; as you may remember, I'm perfectly capable of handling a sword should the need arise. I was thinking later I might go out for a breath of air, take a stroll in the grounds – not that I'm looking for a fight; God forbid; but should you decide to join me, well, we'll see.

DON CARLOS: We will, Don Juan; we will.

Scene Four

SGANARELLE: What the hell was all that about? D'you know Sir I think I preferred you before you were converted – I mean I always used to tell myself you'd give it all up one day, but not now; I despair of you, I really do. God will put up with a lot you know and he certainly has done in your case but there is a limit.

DON JUAN: Oh, I'm not sure God is quite the stickler you think he is; if every time a man –

SGANARELLE: Ah… Sir…; it's a sign – I expect God wants a word with you…he wants to give you your final warning…

DON JUAN: In which case I suggest he expresses himself a little less obscurely.

Scene Five

A GHOST of a veiled woman.

THE GHOST: Don Juan has but moments left to throw himself on God's mercy. Repent, or be damned.

DON JUAN: Repent?

SGANARELLE: That seems pretty clear to me Sir.

DON JUAN: Who do you think you are talking to me like that? That voice sounds very familar… –

SGANARELLE: Sir it's probably a ghost…you can tell by the way they walk –

DON JUAN: I want to see your face.

The GHOST turns itself into a figure of Time, scythe in hand.

SGANARELLE: Oh my God. How did they do that?

DON JUAN: No! No! You think you can terrify *me*? Where's the sword, I'll show you who's flesh and blood and who's a ghost…

In the time that it takes DON JUAN to draw his sword, the figure vanishes.

SGANARELLE: Sir, if I was you, I'd get the message now, and I'd start repenting.

DON JUAN: I said no. No-one is ever – ever!! – going to hear Don Juan apologise for his life. Let's go. I said let's go!

Scene Six

THE STATUE: Stop. Don Juan, yesterday you promised me you'd come and dine at my house.

DON JUAN: I did. And where is that?

THE STATUE: Give me your hand.

DON JUAN: With pleasure.

THE STATUE: Don Juan, a heart hardened by sin dies a miserable death; and for those who reject God's mercy, there remains His wrath.

DON JUAN: Oh God, what is this? I feel as if I'm on fire…
I can't stand it.
My whole body's burning up.
Ah!

A thunderbolt strikes DON JUAN; thunder and lightning; the stage opens and swallows him up; fireworks, as he falls into the pit.

SGANARELLE: Hey! Payday! So, he's dead, and everybody's happy – God, who he offended; the Law, which he broke; all the girls he ever seduced; the

families he tore apart, the parents he humiliated, the
women he drove to distraction, the husbands he drove
to despair – everybody; except me: is that all I get then,
after working for him for *years*; to watch his Lordship
pay for his sins by dying in the most horrifyingly
painful way imaginable. Great. What about my wages?
Eh? Who's going to pay them now? My wages. My
wages!

FIN

Biographies

Neil Bartlett Translator Director and Designer

Don Juan is Neil Bartlett's 22nd show at the Lyric Hammersmith since he became Artistic Director in 1994; others include productions of Wilde, Shakespeare, Shaw, Balzac, Somerset Maugham, Genet, Britten, Rattigan, Robin Maugham, Marivaux, Kleist and Dickens, as well as five Christmas shows. Neil has also made work at, amongst others, the Drill Hall, the ICA, the Vauxhall Tavern, the Derby Playhouse, the Royal Court, the National Theatre, and at the Goodman, Chicago. He was a founder-member of the music-theatre company Gloria, with whom he made 13 new pieces of work including *Sarrasine*, *A Vision of Love*, *Revealed in Sleep* and *Night after Night*. His future plans include a new translation of Genet's *The Maids* for Radio Three and Marlowe's *Dido, Queen of Carthage* at the American Repertory Theatre in Boston.

Bruno Poet Lighting Designer

Previous work at the Lyric Hammersmith includes *The Island of Slaves*, *Pleasure Palaces* and *Hansel and Gretel*. Other theatre work includes *Dumb Show* (Royal Court), *King Lear* (ETT/Old Vic), *The Skin of Our Teeth* (Young Vic), *Midnight's Children* (RSC Barbican, Michigan & New York), *Antartica* (Savoy), *Peter Pan*, *Twelfth Night* and *The Duchess of Malfi* (Dundee Rep), *Volpone*, *Major Barbara*, *The Playboy Of The Western World*, *The Seagull*, *Les Blancs* and *The Homecoming* (Royal Exchange), *Alice In Wonderland* (Bristol Old Vic), *The Birthday Party* (Sheffield Crucible), *Twelfth Night*, *Loves Labours Lost*, *The Cherry Orchard*, *The Taming Of The Shrew* (ETT), *Royal Supreme* and *Musik* (Plymouth Theatre Royal). Opera work includes seven consecutive seasons for Garsington Opera and *Don Giovanni, Rusalka* and *Manon* (Opera North), *Leonore* (Teatro Comunale di Bologna), *The Magic Flute* (Scottish Opera), *Girl Of Sand* (Almeida Opera), *Arabella* and *Fidelio* (De Vlaamse Opera), *La Traviata* and *Fidelio* (ETO), *Orfeo et Euridice* (Opera National du Rhin), *The Turn Of The Screw* (Brighton Festival) and *Norma* (Barcelona).

Nick Manning Sound Designer

Nick trained in Stage Management at the Central School of Speech & Drama and is currently working as the Lyric Hammersmith's Sound Technician. Recent work for the Lyric includes *Oliver Twist*, *Pericles*, *Camille*, *A Christmas Carol*, *The Prince of Homburg*, *Aladdin*, *The Servant*, *Pinocchio* and *The White Devil*. Other work includes *Darwin in Malibu* (Hampstead Theatre), *The Master & Margarita* (National Youth Theatre), *The Andy Warhol Syndrome with Jenny Éclair* (Edinburgh Fringe 2004), *Excuses* (ATC), *Airsick* (The Bush), *Rabbit* (Frantic Assembly), *Great Expectations* (Bristol Old Vic)

and *Out of Our Heads* (ATC). Nick previously worked at Derby Playhouse and The Gordon Craig Theatre where productions included *Cinderella*, *The Wizard of Oz* and *Godspell*.

Cast

James Wilby Don Juan Tenorio

Theatre credits include *Helping Harry* (Jermyn Street Theatre), Alfred Redl in *A Patriot for Me* (RSC), *The Common Pursuit* (Phoenix), *The Tempest*, *Salonika*, *Jane Eyre* (Chichester Festival Theatre), *As You Like It* (Royal Exchange), *Chips With Everything* (Leeds Playhouse), *Who's Afraid of Virginia Woolf* (Belgrade Theatre) and *Another Country* (Queen's Theatre). TV credits include *Island at War* (ITV), *The Woman in White* (ITV), *Trial and Retribution 4* (BBC), *The Dark Room* (BBC), *Crocodile Shoes* (BBC), *Lady Chatterley* (BBC), *A Tale of Two Cities* (Granada) and *Storyteller* (Channel 4). Film credits include *Just One of Those Things* (Delovely Ltd), Freddie Nesbitt in *Gosford Park* (Zestwick Ltd), *Jump Tomorrow* (Jorge/Film 4 Lab), Siegfred Sasson in *Regeneration* (Rafford Films), Charles Wilcox in *Howard's End* (Merchant Ivory), *Immaculate Cnception* (C'est La Vie Productions), Tony Last in *A Handful of Dust* (LWT Films) *Life – A User's Manual* (Jorge / Film 4 Lab), *A Summer Story* and Maurice in *Maurice* (Merchant Ivory).

Giles Fagan Pierrot, Don Carlos, Mr Sunday

Previous work at the Lyric Hammersmith includes *Pericles*. Theatre credits include Buck in *Burleigh Grimes* (Bridewell Theatre), Jerry in *The Zoo Story* (Etcetera Theatre), John in *My Night with Reg* (New Vic Theatre, Stoke) Bill in *Show of Strength* (Tobacco Factory), Mercutio in *Romeo and Juliet*, Algernon in *The Importance of Being Earnest*, Laybach in *He Stumbled* (Riverside Studios and Tour), Al in *American Soap* (RSC Fringe), Valario in *Madness in Valencia,* Valentine in *Twelfth Night* and Francisco in *Hamlet* (RSC). Television credits include *Tough Love* (Carlton) and *The Hunt* (Granada). Radio credits include *Naming the Rose*, *Henry IV*, *Pygmalion* and *Strange Meeting.*

Gregory Cox A Statue

Gregory trained at Bristol Old Vic. Theatre credits include Dr Alan Campbell in *The Picture of Dorian Gray (No 1 UK Tour)*, Charley in *Death of a Salesman* (Frankfurt / English Theatre), Sender Ben Henye in *The Dybbuk* (BAC), Captain Brice in *Arcadia* (National Theatre Tour), Earnest Defarge in *A Tale of Two Cities* (Sheffield Crucible), Harris in *Little Lies* (Wyndham's Theatre), Edmund in *King Lear* (Colchester), Macduff in *Macbeth* (Edinburgh Festival) B Kaghan in *The Confidential Clerk,* Aragon in *The Merchant of Venice* (Everyman Theatre, Cheltenham), Toby Belch in *Twelfth Night* (Wimbledon Theatre)

Claudius in *Hamlet* (Rose) and Mark in *Taking Steps* (Vienna English Theatre) and Mr Sowerberry in *Oliver!* (Albery Theatre). Television credits include *Doctors* (ITV), *Picking up the Pieces* (Carlton), *Killer Net* (La Plante Productions), *The Bill* (Thames), *Grace and Favour, Keeping Up Appearances, Bad Boys* and *Casualty* (BBC). Film credits include *Unmasked* (If Films) and *Making a Killing* (Shining Light).

Felicity Dean Dona Elvira

Theatre credits include *King Lear* (Shakespeare's Globe), *The Coast of Utopia* (National Theatre), *The Three Sisters* (Birmingham Rep), *John Gabriel Borkman* (National Theatre), *Hyde Park, The Churchill Play, The Taming of the Shrew* (RSC), *Good* (RSC London/New York), *An Honourable Trade* (Royal Court), *Hayfever, Pericles, Gaslight, Twelfth Night, Relatively Speaking, The Wicked Old Man, Much Ado About Nothing, The School Mistress* and *Richard III*. Television credits include *The Last of the Blonde Bombshells, Peak Practice* (Carlton), *Casualty* (BBC), *Midsomer Murders, Trial and Retribution III* (La Plante Productions) *The Member for Chelsea, The Trouble with Gregory, Shooting the Chandelier*, Mike Leigh's *Who's Who, The Blue Dress, The Happy Autumn Fields, The Birds Fall Down* and *The Legend of King Arthur* (BBC). Film credits include *The Prince and the Pauper, Return to Munich, Skolimoskys, Success is the Best Revenge, Revolution, Water, The Eye of the Widow, The Whistleblower* and Joseph Losey's *Steaming*.

Paul Ritter Sganarelle

Theatre credits include *Cloud Nine* (Sheffield Crucible), *Christmas* (Ape at the Bush), *The Caretaker* (Bristol Old Vic), *Food Chain, The Night Heron, Bluebird* (Royal Court), *Accidental Death of an Anarchist* (Donmar Warehouse), *The Coast of Utopia, Howard Katz, Remembrance of Things Past, All My Sons* (National Theatre), *The Three Sisters, Troilus and Cressida* (Oxford Stage Company), *Belle Fontaine* (Soho Theatre Company), *The Overcoat* (The Clod Ensemble), *Three Hours After Marriage, The White Devil, Troilus and Cressida* (RSC), *Crossing The Equator, Raising Fires, Darwin's Flood* (The Bush), *Grab the Dog* (RNT Studio), *Seven Doors, The Great Highway, Time and the Room* and *A Little Satire* (Gate Theatre). Television credits include *Peterloo* (RDF Media/Channel 4), *Fields of Gold* and *Big Cat* (BBC), *Out of Hours* (BBC/Monogram), *National Achievement Day, Seaforth, Small Change* (Channel 4) and *The Bill* (Thames). Film credits include *On a Clear Day, The Libertine, Joyrider* (Classic Film Productions), *Esther Khan* (Zenith Films) and *The Nine Lives of Tomas Katz* (Strawberry Vale Television Productions). Radio credits include *Gnomes, Eye of the Day, Greasemonkeys, Agent 52, The Magpie Stories, Agnes Beaumont by Herself, Skin Deep, The Vagabond, The Deep Blue Sea* and *Five Letters to Elizabeth*.

Giles Havergal Dom Louis Tenorio

Giles Havergal has played King Phillip in *Don Carlos*, Spooner in *No Mans Land*, Henry Pulling in *Travels with my Aunt*, Old Lady Squeamish in *The Country Wife*, *Krapp's Last Tape* and many other parts at the Citizens' Theatre, Glasgow of which he was Director with Robert David MacDonald and Philip Prowse from 1969 – 2003. His one-man version of *Death in Venice* originated in Glasgow (2001) and played off-Broadway (2002). His adaptations include *David Copperfield* (Steppenwolf Theater, Chicago 2000), *Les Liaisons Dangereuses* (American Conservatory Theater, San Francisco 2003), *Scoop* (BBC Radio 2002) and the book for the musical *Brighton Rock* (Almeida, 2004). In 2005 he will direct his adaptation of *David Copperfield* at West Yorkshire Playhouse and Bartok's *Bluebeard's Castle* for Opera North.

Kirsty Bushell Charlotte

Kirsty trained at LAMDA. Theatre credits include *Fen/Far Away* (Sheffield Crucible Studio), *Mere Mortals* (Old Red Lion), *The Day That Kevin Came* (Nottingham Playhouse), *Be My Baby* (Soho Theatre Company Tour) Masha in *The Seagull* (Northampton Theatre), Gwendolyn in *The Importance of Being Earnest* (Watermill Theatre), Shelia Birling in *An Inspector Calls* (Garrick Theatre), Antigone in *Antigone*, Lady Macbeth in *Macbeth*, Sophie in *BFG, Wind in the Willows* (Nuffield Theatre), Julia in *The Two Gentlemen of Verona* (National Theatre Education Tour), *Suppliants* (Gate Theatre) and *Blue Heart* (Out of Joint). Television credits include *Eastenders* and *Roger Roger* (BBC). Film credits include *Shotgun Wedding* (Yellow Sky Productions) and *Almost* (Night For Day Productions). Kirsty is also Co-Director of Bspeak Ltd.

Patti Clare Mathurine

Previous work at the Lyric Hammersmith includes *A Christmas Carol*. Theatre credits include *Weighting and Watching* (a one-woman show for Hull Truck), *Crimes and Crimes* (Leicester Haymarket), *Dancing at Lughnasa* (Haymarket, Basingstoke), *Werewolves* (Traverse, Edinburgh), *Lady Windermere's Fan* (Birmingham Rep and West End), *Semi-Monde* (The Lyric, West End), *10 Rillington Place* (Oldham Coliseum) and 23 productions for Citizens Theatre, Glasgow including Catherine in *Suddenly Last Summer*, Hermia in *A Midsummer's Night Dream*, Ellen Bridges in *Cavalcade*, Sophie in the *BFG* and Childie in *The Killing of Sister George*. Radio credits include *Faust* (Open University BBC), three Northern Irish spoken novels for Dan Garrett (BBC) and *The Kate and Naomi Show* (Subcity/Radio 1).

James Bellorini Gusman, Don Alonso, A Poor Man

James trained in BA in Drama at Darlington College of Arts and in France where he performed and directed with a street-theatre company. Theatre credits include *Mandragora King of India* (Tara Arts National Tour 2004), *Onefourseven* (Dende Collective and Oval House), *Under The Earth* (Bodypolitik and BAC), *On Sundays* (Octillo and Union Theatre), *Bald Prima Donna* (The Young Vic Studio), *The Puppetmaster, A Box of Bananas, Epitaph for the Wales* (The Gate), *L'Arte Della Commedia* (Ludque and The Old Vic), *Metamorphosis* (The Deconstruction Company and BAC), *House of Desires* (One Horse Productions and BAC) and *The Merchant of Venice* and *A Christmas Carol* (New Palace Theatre, Westcliff). Television credits include *Treading Water* (Halogen Productions), *R.E.M* (White Cube Productions), *Sirah Double Heartbeat* (Sirah Productions), *Nil By Mouth* and *Eastenders* (BBC). Film credits include *Bridges, Hawker* (Seaview Productions) and *Pokerface* (Raindance Films).